JOHN MUIR'S

GRAND YOSEMITE

Musings and Sketches

CURATION & COMMENTARY
BY MIKE WURTZ

YOSEMITE CONSERVANCY
YOSEMITE NATIONAL PARK

YOSEMITE
CONSERVANCY.

yosemite.org

Yosemite Conservancy inspires people to support projects and programs
that preserve Yosemite and enrich the visitor experience.

Library of Congress Cataloging-in-Publication Data

Names: Muir, John, 1838-1914 author, illustrator. | Wurtz, Michael, 1963-
 editor. | Yosemite Conservancy (Organization), issuing body.
Title: John Muir's grand Yosemite : musings and sketches / [edited and compiled by Mike Wurtz].
Other titles: Grand Yosemite
Description: Yosemite National Park : Yosemite Conservancy, 2020. |
 Includes bibliographical references. | Summary: "The renowned naturalist John Muir spent
 several years in Yosemite and returned there often throughout his life. His early training as
 a botanist instilled in him a keen eye for detail and a talent for representing his surroundings
 in his sketchbooks. Part treasure hunt, part immersive experience, this slender volume shares
 25 places that beckoned Muir to draw them-places he paused in his ramblings and wondered
 over. Thanks to detailed directions and coordinates, visitors to the park can find these spots
 and delight in the incredible scenery that Muir himself enjoyed, often from the same
 enduring spot. JOHN MUIR'S GRAND YOSEMITE also includes Muir's own voice in
 brief selections that accompany the locations; editor Michael Wurtz's engaging commentary
 enlivens the tour"-- Provided by publisher.
Identifiers: LCCN 2019053516 | ISBN 9781930238978 (hardback)
Subjects: LCSH: Yosemite National Park (Calif.)--Pictorial works. | Natural
 history--California--Yosemite National Park--Pictorial works.
Classification: LCC F868.Y6 M895 2020 | DDC 979.4/47--dc23
LC record available at https://lccn.loc.gov/2019053516

Book design by Eric Ball Design
Cover illustrations by Shawn Ball

Printed in China by Toppan Leefung

2 3 4 5 6 – 24 23 22

FOR THE DESCENDANTS
OF JOHN MUIR.

*Muir felt deeply about sharing his Yosemite.
For generations his family has felt, and still feels, deeply
about entrusting his works to the University of the Pacific
to share Muir's message with the world.*

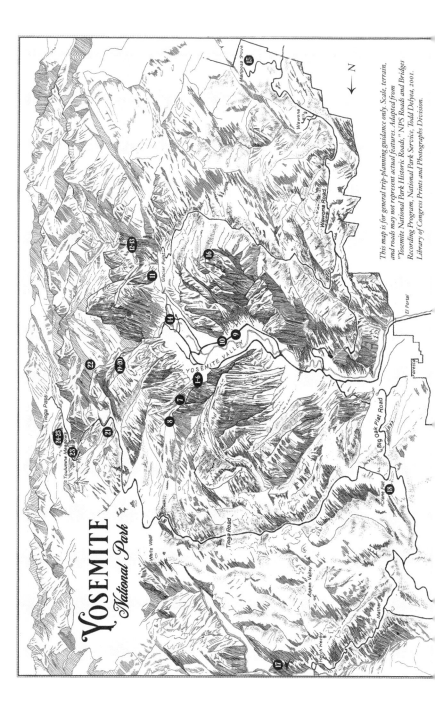

YOSEMITE
National Park

This map is for general trip-planning guidance only. Scale, terrain, and roads may not represent actual features. Adapted from "Yosemite National Park Historic Roads," NPS Roads and Bridges Recording Program, National Park Service, Todd Delyea, 2001. Library of Congress Prints and Photographs Division.

N

Contents

Introduction

JOHN MUIR was the preeminent naturalist at the turn of
the twentieth century. He was a master observer of nature and
had a gift for expressing his observations through his writings
and drawings. He also used his writings to advocate for the
preservation and protection of the environment. The impact he
had and the legacy he left—including inspiration for the national
parks movement—cannot be overstated.

In the summer of 2004, I began working as the archivist at
the University of the Pacific's Holt-Atherton Special Collections
and Archives, where the largest collection of John Muir's letters,
journals, drawings, manuscripts, and records is preserved and
made available for research. Right away, I wanted to get to
know Muir by combining my interest in geography with Muir's
experience in a way that would help me create a "sense of
place"—that feeling one can get when standing, quite literally,
where history was made.

My first journey to this end was in the fall of 2005, when I
hiked to Cathedral Lakes in the high country of Yosemite
National Park and read passages of Muir's adventures in 1869
of climbing Cathedral Peak. Then, I was thrilled to find
photographs of Muir taken throughout California, and I sought
to stand where he had. My first attempt at determining one of his
drawing sites was in 2009 while visiting the "Old dead giant" in
the Tuolumne Grove with a class of Pacific students. Thereafter,

whenever I visited Yosemite National Park, whether on my own or co-leading Pacific's geology classes or Osher Lifelong Learning Institute field trips, I brought along Muir's drawings to "geolocate."

As I identified drawing sites, I connected more and more with Muir. Each time I found a new location, I was energized! There were moments when I would line up the landscape with one of Muir's illustrations and I'd look down to find I was standing on a huge, flat rock that Muir had to have sat upon to make his drawing. I tend to see myself more along the lines of Muir's description of famed botanist Asa Gray ("the angular factiness of his pursuits have kept him at too cold a distance from the spirit world"), but when I sit where Muir sat, I connect to that Muir sense of place on a deep emotional level.

I was also energized when I shared my latest discovery with my travel companions—or with complete strangers! I couldn't help adding context, whether a quote from Muir or tidbits of geology, history, or park culture. A highlight was a visit to Taft Point with one of my brothers and some friends. We spent time exchanging stories of Muir and Yosemite and then concluded our visit by "Muiring" the view; that is, we lay on our backs to look at the Valley "from a new perspective, or from an old one with our head upside down."

· HOW TO USE THIS BOOK ·

This book provides you with directions and coordinates to either the exact spots where Muir stood or, sometimes, to a safer and/or less ecologically destructive location nearby (latitude and longitude have been rounded to the nearest second, which is about 100 feet or 30 m on the ground). Yosemite has amazingly strong granite walls, but the rest of the ecosystem—especially the plants, soils, critters, and riparian areas—are fragile. Consider that a single step off a maintained trail could have an impact for future visitors.

In the pages that follow, I have paired twenty-five Muir drawings with passages intended to propel you back in time. Twenty-three are from Muir's own reflections (some edited for brevity or clarity) and the other two feature writings by President Theodore Roosevelt and Josiah Whitney, State Geologist of California during Muir's time. I've followed those passages with some brief commentary of my own—my way of sharing some of my favorite facts about John Muir, Yosemite, geology, and history, just as I would if we met along the trail. I hope this book helps you find your own Muir sense of place.

· TAKE CARE ·

This is no longer John Muir's Yosemite. In many ways, it is safer now than in Muir's time (think of the cables on Half Dome), but there are also new dangers (such as the temptation to, say, take a selfie at the edge of a thousand-foot cliff). Always observe park rules and both permanent and temporary signage, and exercise extreme caution on steep slopes and high points, and especially around water in any of its forms: ice, snow, clouds, fog, mist; or in rivers, creeks, lakes, ponds, and even gutters and potholes. Also keep an eye out for traffic, animals, and other humans, and please note that the flying of drones is prohibited in national parks. Don't forget to grab a trail map and compass for your adventure.

Muir was known for taking risks, but they were always calculated risks. He famously wrote, "The mountains are calling and I must go and I will work on while I can, studying incessantly." So, yes, heed the call of the mountains, but work on to protect yourself and study your surroundings incessantly.

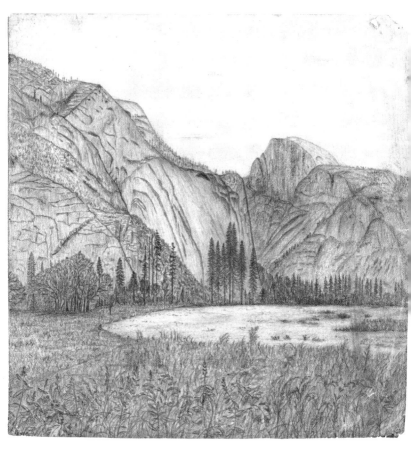

"Untitled" (North Dome, Royal Arches, Washington Column, Half Dome, Cook's Meadow), ca. 1870.

Half Dome
and Cook's Meadow

This scene is visible from the east end of the Lower Yosemite Fall Trail where it intersects with the Cook's Meadow Loop. Muir lived nearby during his early years in Yosemite, and he made many drawings from this area. 37°44'46" N 119°35'35" W

· MUIR PASSAGE ·

Once arrived in the valley, it is important to know what to do with one's self. I would advise sitting from morning till night under some willow bush on the riverbank where there is a wide view. This will be "doing the valley" far more effectively than riding along trails in constant motion from point to point. Sunlight streaming over the walls and falling upon the river and silvery foliage of the groves; the varied rush and boom of the falls; the slipping of the crystal river; birds, flowers, and blue, alpine sky, are then seen most fully and impressively, without the blurring distractions of guiding, riding, and scrambling. Few, however, will believe this, and anxious inquiries will always be made for ponies, points, and guides.

· COMMENTARY ·

Half Dome looms over most of the Valley's trails, and campers in the Upper, Lower, and North Pines campgrounds await late sunrises in its shadow. Spend enough days in the Valley, however, and it's possible to stop noticing it. Muir observed a similar phenomenon when traveling in Alaska and had a solution to combating this comfortable familiarity: "All that is necessary to make any landscape visible and therefore impressive is to regard it from a new point of view or from an old one with our head upside down—then we behold a new heaven and earth and are born again as if we had gone on a pilgrimage to some far off holy land." Try it.

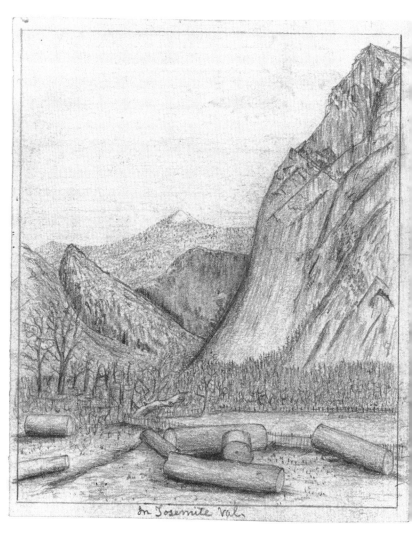

"In Yosemite Val.," ca. 1870.

Glacier Point

· LOCATION ·

This vista is visible from the east end of the Lower Yosemite Fall Trail where it intersects with the Cook's Meadow Loop. Muir lived nearby during his early years in Yosemite, and he made many drawings from this area. 37°44'46" N 119°35'35" W

· ROOSEVELT PASSAGE ·

My dear Mr. Muir: I trust I need not tell you, my dear sir, how happy were the days in the Yosemite I owed to you, and how greatly I appreciate them. I shall never forget our three camps; the first in the solemn temple of the giant sequoias; the next in the snow storm among the silver firs near the brink of the cliff [at Glacier Point]; and the third on the floor of the Yosemite, in the open valley, fronting the stupendous rocky mass of El Capitan, with the falls thundering in the distance on either hand. Good luck go with you always. *Faithfully yours, Theodore Roosevelt*

· COMMENTARY ·

On what was considered one of the most famous camping trips in U.S. history, Muir, California governor George Pardee, and President Theodore Roosevelt visited Yosemite together in May of 1903. Although Roosevelt wanted to "drop politics absolutely," Muir lobbied both the president and the governor in hopes that the Valley and the Mariposa Grove—both of which had been under the protection of the state since 1864—would be returned to the federal government as part of Yosemite National Park. His work eventually paid off, and the Yosemite Recession Bill was finalized in 1906. Three years later, Muir also toured President Taft through Yosemite, hoping to convince him to prevent building the Hetch Hetchy reservoir within the bounds of the park.

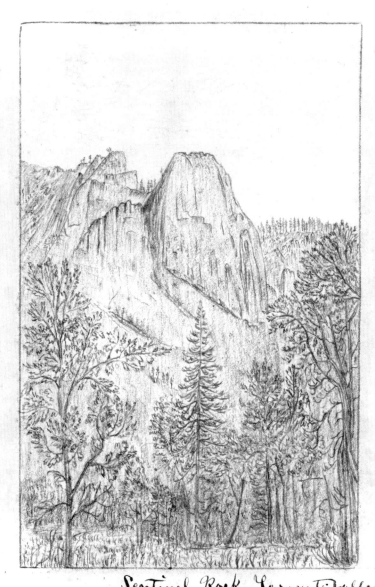

"Sentinel Rock, Yosemite Valley," ca. 1875.

Sentinel Rock

This view is visible from the east end of the Lower Yosemite Fall Trail where it intersects with the Cook's Meadow Loop. Muir lived nearby during his early years in Yosemite, and he made many drawings from this area. 37°44'46" N 119°35'35" W

· MUIR PASSAGE ·

The earthquake's shocks were so violent and varied and succeeded one another so closely, that I had to balance myself carefully in walking as if on the deck of a ship among waves, and it seemed impossible that the high cliffs of the Valley could escape being shattered. In particular, I feared that the sheer-fronted Sentinel Rock, towering above my cabin, would be shaken down, and I took shelter back of a large yellow pine, hoping that it might protect me from at least the smaller outbounding boulders. For a minute or two the shocks became more and more violent— flashing horizontal thrusts mixed with a few twists and battering, explosive, upheaving jolts—as if Nature were wrecking her Yosemite temple and getting ready to build a still better one.

· COMMENTARY ·

When the 1872 Owens Valley earthquake (of similar intensity to the famous 1906 San Francisco earthquake) began to shake at 2:30 a.m. on March 26, Muir rushed outside to watch under a full moon. He ran up valley to see the "newborn talus" and then returned to speak to fearful residents and visitors. As the sun rose, there were continuing aftershocks that made the cliffs "tremble like jelly," and that was not the end of it. "The rocks trembled more or less every day for over two months," he wrote, "and I kept a bucket of water on my table to learn what I could of the movements."

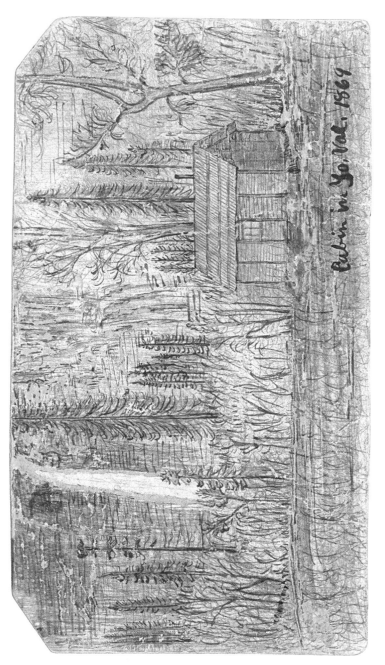

"Cabin in Yo. Val.," 1869.

Cabin Site on Yosemite Creek

Follow the Lower Yosemite Fall Trail counterclockwise for about 500 feet (150 m) from its east end at Northside Drive. This view site is within a 400 foot (120 m) stretch along this section of the trail. 37°44'51" N 119°35'34" W

· MUIR PASSAGE ·

From the Yosemite Creek near where it first gathered its beaten waters at the foot of the fall, I dug a small ditch and brought a stream of water into the cabin, entering at one end and out the other, with just current enough to allow it to sing and warble in low, sweet tones, delightful at night while I lay in bed. The floor was made of rough slabs, nicely joined and embedded in the ground. In the spring the ferns pushed through between the joints of the slabs. Dainty little climbing tree frogs occasionally climbed the ferns and made fine music in the night, and there common frogs came in with the stream and helped to sing with the Hylas.

· COMMENTARY ·

In the 1920s, the California Conference of Social Work, guided by Muir's first biographer, William Frederic Badè, installed a brass plaque to commemorate the spot where Muir had supposedly built his cabin in 1869. You can find the monument close to the middle of the braided Yosemite Creek below the base of Yosemite Falls. However, this drawing (featured on the plaque itself) doesn't quite match the location as described in other sources. Continued research with maps, letters, photographs, and conversations with Muir enthusiasts, make it clear that Muir had dug the ditch (mentioned in the excerpt above) on the far eastern edge of the creek. By 1871, Muir had moved into what was called his "hang nest," attached to the side of the sawmill, closer to the falls.

It is hard to write here as the mill jars so much by the stroke of the saw & rain drips from the roof & I have to set the log every few minutes. I am operating this same mill that I made last winter. I like the piney fragrance of the fresh sawn boards, & I am in constant view of the grandest of all the falls. I sleep in the mill for the sake of hearing the murmuring hush of the water beneath me, & I have a small box-like house fastened beneath the gable of the mill looking westward down the valley where I keep my notes etc people call it the hang nest because it seems unsupported thus. Fortunately the only people that I dislike measure—

"The hang nest," 1871.

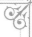

Sawmill Site on Yosemite Creek

Start at the eastern trailhead of the Lower Yosemite Fall Trail and walk approximately .3 miles (.5 km) to the interpretive sign near the former site of the sawmill. 37°45'1" N 119°35'37" W

· MUIR PASSAGE ·

I sleep in the mill for the sake of hearing the murmuring hush of the water beneath me, and I have a small box-like home fastened beneath the gable of the mill, looking westward down the Valley, where I keep my notes, etc. People call it the hang nest, because it seems unsupported. Fortunately the only people that I dislike are afraid to enter it. The hole in the roof is to command a view of the glorious South Dome, 5000 feet high. There is a corresponding skylight on the other side of the roof which commands a full view of the upper Yosemite falls, and the window in the end has a view sweeping down the Valley among the pines and cedars and silver firs. The window in the mill-roof to the right is above my bed, and I have to look at the stars on calm nights.

· COMMENTARY ·

In Muir's time, as today, many people wondered how someone who loved trees so much could work in a sawmill. He explained himself in a letter to the *Oakland Daily Evening Tribune*: "I would state that twenty years ago I was employed by the month, by Mr. Hutchings, to saw lumber from fallen timber, with which to build cottages in the Valley. I never cut down a single tree in the Yosemite, nor sawed a tree cut down by any other person there. Furthermore, I never held or tried to hold any sort of claim in the Valley or sold a foot of lumber there or elsewhere."

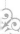

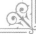

"From back of foot of Lower Yosemite Fall," ca. 1869.

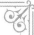

LOWER YOSEMITE FALL

The best place to understand this view is from the bridge at the base of Lower Yosemite Fall, approximately .5 miles (.8 km) from the eastern trailhead of the Lower Yosemite Fall Trail.
37°44'59" N 119°35'45" W

· MUIR PASSAGE ·

Every bright morning in the springtime, the black walled recess at the foot of the Lower Yosemite Fall is lavishly filled with irised sprays. When observed from a distance of 200 yards or thereabouts, the irised portion of the foam and spray is about 50 feet high and more than 100 yards wide and of wonderful beauty seen against the black wet cañon wall. Nor is this broad arc of foam bow motionless. The bow does not seem to simply span the tumultuous dashing foam, but the foam itself seems colored and drifts from color to color in a manner that does not suggest any relationship with the ordinary rainbow. This is perhaps the most reservoir-like accumulation of color to be found in the Valley.

· COMMENTARY ·

Muir tells fascinating stories about all kinds of bows: rainbows, "foam bows," and moon "bows" appearing in all three cascades of Yosemite Falls. The excerpt above focuses on the Lower Fall, but his famous story about standing behind a waterfall to watch the moon took place at the base of Upper Yosemite Fall. He started on Fern Ledge and sidled along the rock until he was behind the waterfall, where he stayed upright for only a moment before the wind started to push the cascade back against him. He had to curl up "like a young fern frond with my face pressed against my breast" to survive the "thundering bath." And in the Middle Fall, he spotted a foam bow late at night.

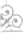
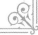

with astonishing vividness in the
kern white sunglass.

The up fall swayed away from
the face of the wall then clashed
against it or vibrated from
side to side in yielding many
extraordinary tones in sympathy
with the storm Watts above
Grand Sunny this
blend

When I saw that
the fall was so frequently
driven west by the force
of the wind I thought
by climbing to shelf & more
above the
base I might see down
into the mouth of the ice
cone, This Standpoint
where I have so often spread
nights & days, is about one
H above Sunset

I set out at noon
all the way up the stream
notes of the wind almost
drowned them of the fall

CLARK RANGE

For a perspective similar to the one in this sketch, walk 1.5 miles (2.4 km) up the Yosemite Falls Trail from the trailhead at Camp 4. 37°45'18" N 119°36'05" W

· MUIR PASSAGE ·

When I had reached an elevation above Sunnyside, the tips of the mountains of the Merced group [Clark Range] began to rise above the curve between South Dome and Mount Starr King. These were adorned as I had never seen them before. From the thin wave-like summit of Mount Clark and the sharp pyramid-like point of Gray Mountain, there streamed a splendid white banner of splendid dimensions. These banners were at first bent upward then continued with sublime motion horizontally for a length of at least 3000 feet. Seen against the blue sky, the effect was indescribably grand.

· COMMENTARY ·

Muir's journals and notebooks are filled with sketches that look much like this one, as opposed to the more polished drawings featured throughout this book. When Muir made this sketch in early 1873 he used the term "snow banners" to describe this phenomenon of snow blowing off the peaks. He later published an article about them, including a drawing from a different perspective. His writing began to pull him away from Yosemite, and by the end of 1873 Muir had effectively ended his full-time residences in the Valley in order to extend his "winter work in Oakland with my pen."

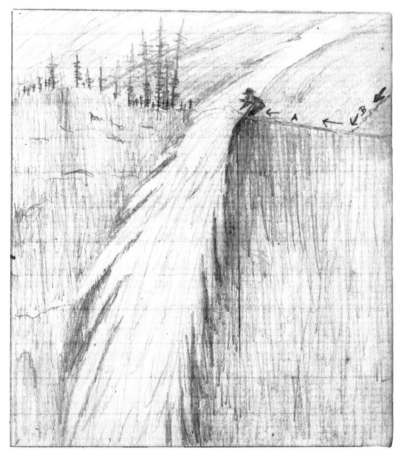

"Point of observation," ca. 1887.

Top of Yosemite Falls

· LOCATION ·

For the best approximation of this view (which Muir himself imagined from a perspective of open air about 2,400 feet [730 m] above the Valley floor), walk about 2.6 miles (4.2 km) up the Yosemite Falls Trail until you are at the top, above the falls, and then take the short and steep trail to its end.

37°45'25" N 119°35'49" W

· MUIR PASSAGE ·

While perched on that narrow niche I was not distinctly conscious of danger. The tremendous grandeur of the fall in form and sound and motion, acting at close range, smothered the sense of fear, and in such places one's body takes keen care for safety on its own account. How long I remained down there, or how I returned, I can hardly tell. Anyhow, I had a glorious time and got back to camp about dark, enjoying triumphant exhilaration soon followed by dull weariness. Hereafter, I'll try to keep from such extravagant, nerve-straining places.

· COMMENTARY ·

On July 15, 1869, Muir crept out to the edge of the top of Yosemite Falls to "see the forms and behavior of the fall all the way down to the bottom," 2,400 feet (740 m) below. That night, after this harrowing observation, he dreamed of falling into the Valley: "One time, springing to my feet, I said, 'This time it is real, all must die, and where could a mountaineer find a more glorious death!'" What he did was dangerous and certainly nightmare fodder, and often he admits the danger of what he's done in the name of observation. However, he also proclaims that he would prefer these challenges in nature compared to death in the "doleful chambers of civilization."

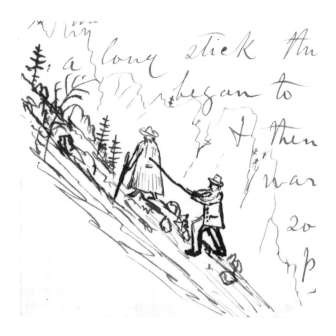

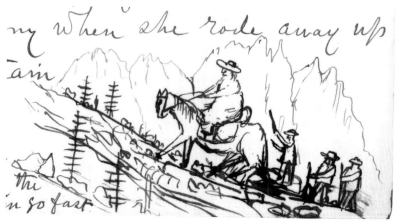

From a letter from John Muir to Wanda Muir, 1884.

Four Mile Trail

The coordinates will take you to the lower trailhead of the Four Mile Trail, but the events described in this letter could have happened along this or another trail leading from the Valley floor to Glacier Point. 37°44'01" N 119°36'06" W

· MUIR PASSAGE ·

Mamma and Papa climbed up a high mountain and Mamma got tired and so Papa walked behind and pushed Mamma with a long stick this way and the stick soon began to hurt Mamma's back and then Mamma was too warm and so she took off some of her clothes and Papa tied a shirt on the end of the stick and then it did not hurt any more. And when we were about half way up the mountain a man came up behind us and jumped down off his horse and said to Mamma "Please get on my horse, Mrs. Muir," and there was a big man's saddle on the horse and some big bags that are called saddlebags and some meat and things in the bags but Mamma got on the top of all and she looked very funny when she rode away up the mountain with the man behind with a stick whipping the horse to make him go fast.

· COMMENTARY ·

Muir wrote the above letter to his three-year-old daughter Wanda on the occasion of her mother's only trip to Yosemite. It is fairly plain that her mother, Louie, may not have enjoyed at least one of the trails. They both missed their daughter terribly and returned home early. Louie was married to Muir for twenty-five years. She was always supportive of his "mountain work," though she usually stayed home with their two daughters and attended to the family's fruit ranch in Martinez, California, while her husband traveled to the wilderness, often for months at a time.

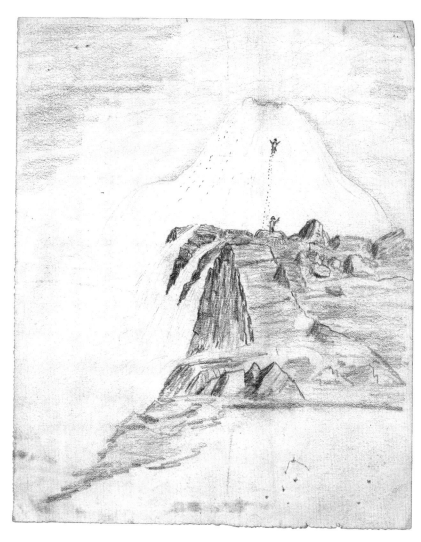

"Ice cone at foot of Upper Yosemite Fall," ca. 1890

BASE OF
UPPER YOSEMITE FALL

· LOCATION ·

As with the image on page 24, Muir imagined this view based on what it would look like from about 1,000 feet (300 m) above the Valley floor. A good place to get a similar view, albeit from farther away, is on the bicycle trail along Southside Drive, 900 feet (275 m) east of the Swinging Bridge parking area. Bring your binoculars. 37°44'15" N 119°35'50" W

· MUIR PASSAGE ·

The frozen spray of Upper Yosemite Fall gives rise to one of the most interesting winter features in the Valley—a cone of ice at the foot of the fall, four or five hundred feet high. It is built during the night and early hours of the morning. The greater part of the spray material falls in crystalline showers direct to its place, something like a small local snowstorm. While the cone is in process of formation, growing higher and wider in the frosty weather, it looks like a beautiful, smooth, pure-white hill.

· COMMENTARY ·

The Valley in wintertime exhibits other unusual sights in addition to the ice cone, such as frazil ice, a kind of slush that forms and flows at the bases of several waterfalls, which is as beautiful as it is rare. There is also the celebrated display at Horsetail Fall: for a few evenings in February, photographers descend on the area between the Yosemite Valley Lodge and El Capitan Meadow to capture the perfect combination of sufficient water flow and an unobscured sunset lighting up the fall, giving it the appearance of being on fire.

"Illilouette Fall in winter," ca. *1887.*

Illilouette Fall

· LOCATION ·

There is no trail to where Muir made this drawing, but Illilouette Fall is narrowly visible from a similar perspective about .6 miles (1 km) up the John Muir Trail from Happy Isles Loop Road. 37°43'34" N 119°33'23" W

· MUIR PASSAGE ·

When I reached the foot of Illilouette Fall, sunbeams were glinting across its head, leaving all the rest of it in shadow; and on its illumined brow, a group of yellow spangles of singular form and beauty were playing, flashing up and dancing in large flame-shaped masses, wavering at times, then steadying, rising and falling in accord with the shifting forms of the water. But the color of the dancing spangles changed not at all. Nothing in clouds or flowers, on bird-wings or the lips of shells, could rival it in fineness. It was the most divinely beautiful mass of rejoicing yellow light I ever beheld—one of Nature's precious gifts that perchance may come to us but once in a lifetime.

· COMMENTARY ·

The Ahwahneechee, who lived in Yosemite Valley at the time of contact with European Americans, may have called this creek and fall "Tululowehäck," from which may have come the modern name "Illilouette." Other names in Yosemite have changed over time, too: for instance, Muir interchangeably used "Half Dome," "South Dome," and the Ahwahneechee name "Tissiack" to describe the same feature. Names operate on a human timescale; they help us with directions and sometimes instill a romantic or grim understanding of history or geography. Fear not! Regardless of names, Yosemite's natural features change on a geological timescale and will barely alter over the course of our lives.

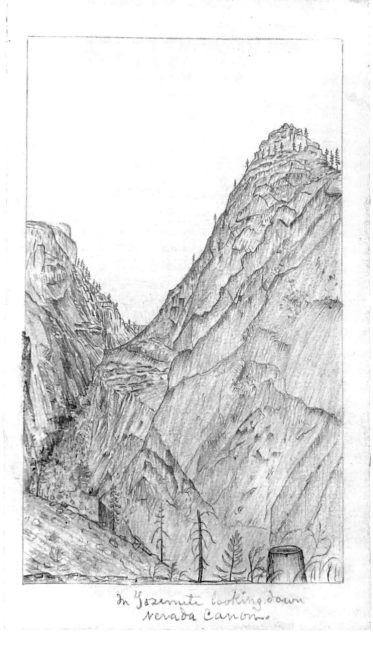

"In Yosemite looking down Nevada Canon," ca. 1873.

Merced Canyon, Glacier Point, and Grizzly Peak

From Happy Isles Loop Road, follow the Mist Trail for approximately 1.6 miles (2.6 km) up toward Nevada Fall. Right before the bridge that crosses the Merced River between Vernal Fall and Nevada Fall you can catch a view similar to the one in this Muir sketch. 37°43'34" N 119°32'26" W

· MUIR PASSAGE ·

Thousands of joyous streams are born in the snowy range, but not a poet among them all can sing like Merced. The Merced was born a poet. A perfect seraph among its fellows. The first utterances of its childhood are sweet uncommon song, and in its glorious harmonies of manhood it excels all the vocal waters of the world, and when its days of mountain sublimity are past in quiet age down on the plains amid landwaves of purple and gold its lifeblood throbs with poetic emotion and with a smooth sheet of soft music it hushes and tinkles and goes to death in a maze of dipping willows and broad green oaks—an Amazon of thoughtfulness and majesty.

· COMMENTARY ·

As narrow as it is in the vicinity of the popular Mist Trail, the Merced River Canyon has featured some of Yosemite's earliest trail projects. Ladders for getting to the top of Vernal Fall were installed in 1857, and steps were cut into the rock in 1897. As early as 1869, a toll road was built from the top of Vernal Fall to the base of Nevada Fall to service a hotel. The John Muir Trail, which goes from the Valley, through this canyon, and to the top of Mount Whitney 211 miles (340 km) away, was completed in 1938. Long before these trails were constructed, human travelers were enjoying the music of the Merced as they followed the river to and from the Yosemite high country.

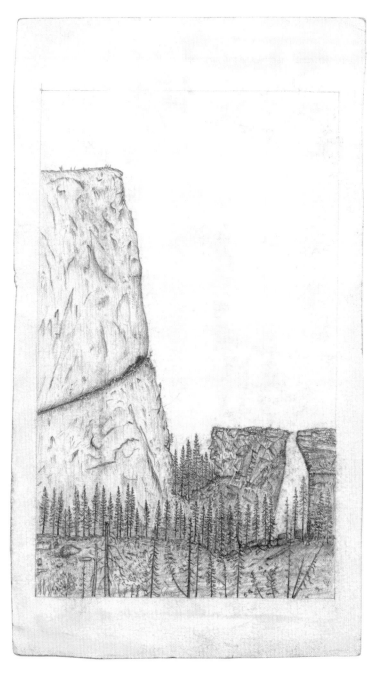

"Untitled" (Liberty Cap and Nevada Fall), ca. 1873.

LIBERTY CAP AND NEVADA FALL

· LOCATION ·

From Happy Isles Loop Road, follow the Mist Trail for approximately 1.6 miles (2.6 km) up toward Nevada Fall. Right before the bridge that crosses the Merced River between Vernal Fall and Nevada Fall you can catch a view similar to the one in this Muir sketch. 37°43'34" N 119°32'26" W

· MUIR PASSAGE ·

Coming through the Little Yosemite Valley in tranquil reaches, the Merced River is first broken into rapids on a moraine boulder-bar that crosses the lower end of the valley. Thence it pursues its way to the head of Nevada Fall in a rough, solid rock channel, dashing on side angles, heaving in heavy surging masses against elbow knobs, and swirling and swashing in pot-holes without a moment's rest. Thus, already chafed and dashed to foam, over-folded and twisted, it plunges over the brink of the precipice as if glad to escape into the open air. But before it reaches the bottom it is pulverized yet finer by impinging upon a sloping portion of the cliff about half-way down, thus making it the whitest of all the falls of the Valley, and altogether one of the most wonderful in the world.

· COMMENTARY ·

Albert and Emily Snow built the Alpine House, later La Casa Nevada, on the large, flat area below Nevada Fall in the 1870s. Muir signed its guest book in 1873 with a long story of his party's trip to Glacier Point, concluding his entry with, "We reached Snows' weary with delight and the Nevada sang us asleep." The Snows stopped running the hotel in 1889, and after a few years it became more of a stopping point than an overnight accommodation. The building burned to the ground in 1900, but the location is still a fine place to pause "weary with delight."

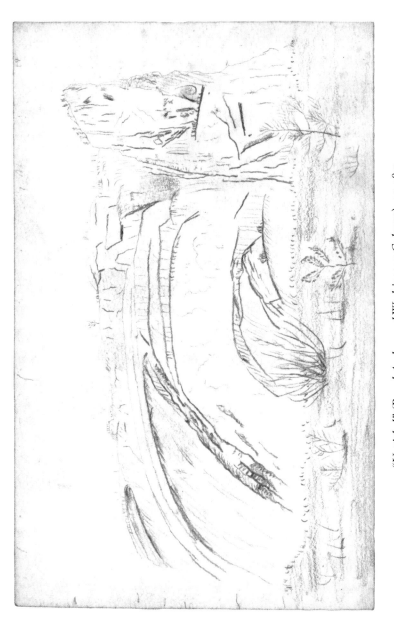

"Untitled" (Royal Arches and Washington Column), ca. 1873

Royal Arches

A similar view to Muir's can be found on the southwestern end of the Happy Isles Loop Road bridge as it crosses the Merced River about 165 feet (50 m) east of the entrance to the Lower Pines Campground. 37°44'22" N 119°33'54" W

· MUIR PASSAGE ·

Santa Claus came with very little ado, gave trinkets to our half-dozen younglings, and dropped crusted cakes into bachelors' cabins; but upon the whole our holidays were sorry, unhilarious, whiskified affairs. A grand intercampal Christmas dinner was devised on a scale and style becoming our peerless Valley; heaps of solemn substantials were to be lightened and broidered with cookies and backed by countless cakes, blocky and big as boulders, and a craggy trough-shaped pie was planned for the heart and soul of the feast. It was to have formed a rough model of Yosemite, with domes and brows of "duff" and falls of buttering gravy. "South Dome be mine," cried one, "softened with sauce of Pohono." "I'll eat Royal Arches," cried another, "salted with Bachelor's Tears."

· COMMENTARY ·

Why might the Royal Arches look so edible? Yosemite's steep walls are made up of igneous rock that solidified deep underground between 100 and 180 million years ago. About 10 million years ago, the Sierra Nevada started rising above surrounding terrain, and erosion began stripping away the old metamorphic rocks on top to eventually reveal the granite we see today. Streams and rivers cut deep canyons, and then during the past 2 million years, repeated glacial advances scraped clean the deep river valleys. Glaciers grinding their way through the Valley plucked away the lower layers of this wall as if peeling an onion, leaving a series of delicious arches.

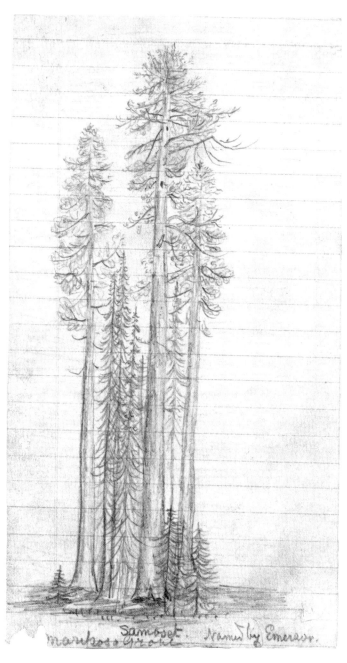

"Samoset. Mariposa Grove. Named by Emerson," 1875.

Mariposa Grove of Giant Sequoias

To locate the tree featured in Muir's sketch: from the Mariposa Grove Arrival Area shuttle stop, walk 1 mile (1.6 km) up to the Grizzly Giant tree. From there follow the Mariposa Grove Trail to the first intersection with the Guardians Loop Trail, 2.5 miles (4 km) from the Arrival Area. The tree is about 150 feet (45 m) above the intersection, and the side portrayed faces away from the trail. 37°30'52" N 119°35'57" W

· MUIR PASSAGE ·

I thought that I would postpone my South American trip and go to California to see Yosemite and the big trees and the vegetation in general. After getting out and making our way over the snow to Wawona without any tracks to guide us, we went on up to the celebrated Mariposa Grove of Big Trees. The longer we gazed at these sequioa giants, the more we admired their immense size. Being the greatest of all living things, they make even the gigantic firs and pines look like mere weeds growing among corn.

· COMMENTARY ·

Muir saw giant sequoias for the first time in 1868, when he visited the Mariposa Grove. He returned to the grove in 1871 with famed transcendentalist Ralph Waldo Emerson, who named this tree Samoset, after the first Native American to make contact with the pilgrims at New England's Plymouth Colony in 1620. Muir himself did not like the practice of naming the trees or, worse, scarring them with "black glaring names carved on marble tablets and counter-sunk in the brown bark, producing a shabby, tombstone appearance." Muir might appreciate that naming trees has fallen out of favor in Yosemite.

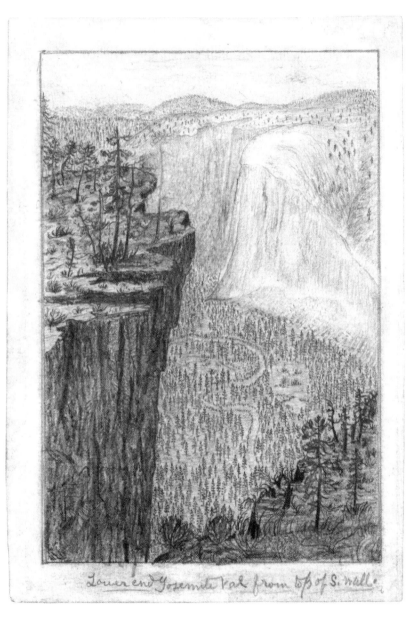

"Lower end Yosemite Val. from top of s. wall," ca. 1870.

PROFILE CLIFF, TAFT POINT, AND EL CAPITAN

· LOCATION ·

From the Sentinel Dome/Taft Point trailhead, hike approximately .9 miles (1.4 km) on Taft Point Trail. A comparable view is found as the trail pops out of the woods before the Fissures.
37°42'40" N 119°36'07" W

· MUIR PASSAGE ·

Just beyond this glorious flood of Ribbon Fall or Virgin's Tears, the El Capitan Rock, regarded by many as the most sublime feature of the Valley, is seen through the pine groves, standing forward beyond the general line of the wall in most imposing grandeur, a type of permanence. It is 3300 feet high, a plain, severely simple, glacier-sculptured face of granite, the end of one of the most compact and enduring of the mountain ridges, unrivaled in height and breadth and flawless strength.

· COMMENTARY ·

In the 1950s, the first successful ascent of El Capitan's nearly vertical granite prow route called The Nose took a team of men forty-seven days spread out over sixteen months. In 1993, Lynn Hill proclaimed, "It goes, boys!", when she became the first person to successfully "free climb" The Nose (meaning she used ropes and other climbing aids only to protect herself from a catastrophic fall). In the decades that followed, many climbers have summited the monolith in less than a day. In 2017, professional climber Alex Honnold completed the first "free solo" climb of El Cap—meaning without the aid or protection of ropes or anchors—in under four hours.

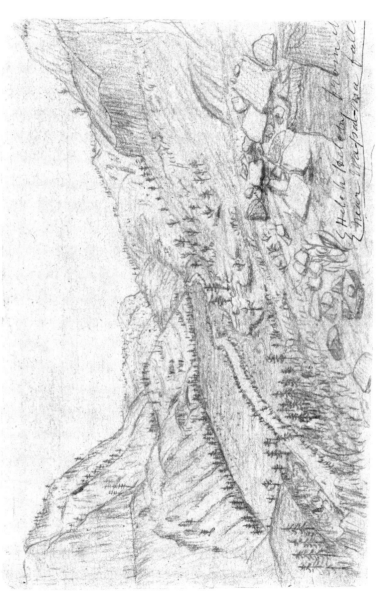

"Hetch Hetchy from near Wa-pa-ma Falls," ca. 1895.

Hetch Hetchy Valley

· LOCATION ·

From the O'Shaughnessy Dam trailhead, hike approximately
2.3 miles (3.7 km) on the Wapama Falls Trail. Muir likely drew this
scene from the large, flat rock on the reservoir side of the trail
right before the bridges at the falls. 37°57'47" N 119°46'01" W

· MUIR PASSAGE ·

This valley is about three-quarters mile wide, dry and ferny at
the head with azaleas, alders, and conifers along the river. In the
middle, the densest groves of alder and young cedar are so close,
it is difficult getting through. Big Rock Creek [likely today's Falls
Creek] is about twice the size of Yosemite Creek. It divides this
big delta into two main branches. The largest to the west is easily
crossed on a big, old jam of logs which has withstood every flood
for many years on account of four trees growing in rocks about ten
feet apart. Had a feast of raspberries on its banks where the bears
had been feasting before me—very abundant. Vegetation as in
Yosemite Valley.

· COMMENTARY ·

In 1906, the San Francisco earthquake triggered a massive fire that
destroyed most of the city. Immediately, the city sought to bolster
its water supply by damming the Tuolumne River and turning
Yosemite's Hetch Hetchy Valley into a reservoir. Muir fought
tirelessly against the project and lost—"Dam Hetch Hetchy! As
well dam for water-tanks the people's cathedrals and churches, for
no holier temple has ever been consecrated by the heart of man."
The dam was completed in 1923. The need for the dam to be inside
the park continues to be questioned and studied.

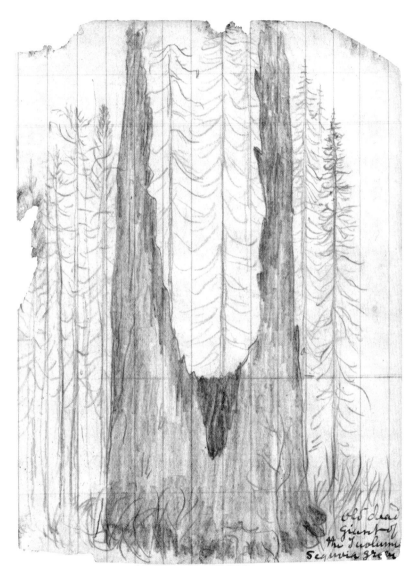

"Old dead giant of the Tuolumne Sequoia grove," ca. 1869.

TUOLUMNE GROVE
OF GIANT SEQUOIAS

· LOCATION ·

From the Tuolumne Grove trailhead at Crane Flat on Highway
120, walk approximately 1.3 miles (2 km) down the Tuolumne
Grove Trail. Now Muir's "old dead giant" is called Dead Giant or
Tunnel Tree. 37°46'7" N 119°48'22" W

· MUIR PASSAGE ·

I found a black charred stump about thirty feet in diameter and
eighty or ninety feet high—a venerable impressive old monument
of a tree that in its prime may have been the monarch of the grove;
seedlings and saplings growing up here and there, thrifty and
hopeful, giving no hint of the dying out of the species. Not any
unfavorable change of climate, but only fire threatens the existence
of these noblest of God's trees. Sorry I was not able to get a count
of the old monument's annual rings.

· COMMENTARY ·

A tunnel was bored through this snag in 1878, and visitors could
drive through it until 1962, when this section of Big Oak Flat
Road was diverted. The road was closed to all vehicle traffic in
the 1990s and is now a paved trail. Muir had a strong affinity for
giant sequoias, the most massive single-trunk trees in the world.
Initially he approached the species with awe, then he explored
them to understand their natural history, and lastly he fought to
preserve their groves. Contrary to Muir's quote above, fire is vital
to the propagation of these trees, and climate change is a very real
threat to their survival.

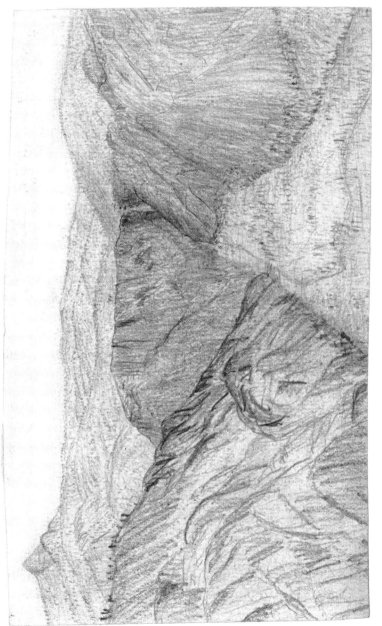

"Illilouette Fall," ca. 1872.

PANORAMA CLIFF

A view similar to Muir's can be found by following the trail to North Dome from the Porcupine Creek trailhead on Tioga Road for 5.2 miles (8.4 km) to the summit. 37°45'20" N 119°33'37" W

· MUIR PASSAGE ·

I encamped for about six weeks in a fine grove of silver firs about a mile to the north of the north Yosemite dome. During most of this time I set out every morning after breakfast, with a piece of bread for luncheon, and spent the day on the dome sketching. From the top of the dome almost every feature of the Valley is in plain sight, and I was eager to draw every rock in the walls, with all its trees, and falls, and the meadows; and in fact to try to get an exact set of sketches which would show every peculiarity of the great temple.

· COMMENTARY ·

John Muir was a scientist, but that didn't hinder his ability to experience what he describes as almost supernatural moments. One time, Muir was "hard at work with [his] pastels" atop North Dome when he was overcome with a feeling that Professor James D. Butler of the University of Wisconsin, where Muir had studied a few years before, was nearby. He ran down through brush and scrambled down steep cliffs and found Butler, who had entered the Valley at almost the exact moment Muir had looked down into the Valley from North Dome and sensed his presence.

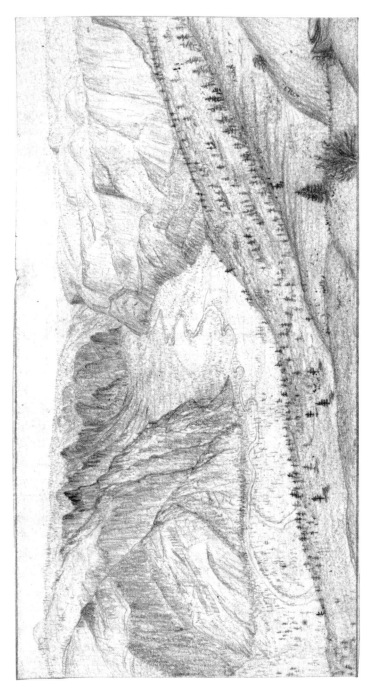

"Yosemite Valley from top of North Dome," 1869.

YOSEMITE VALLEY VIEW

· LOCATION ·

A vista similar to Muir's can be found by following the trail to
North Dome from the Porcupine Creek trailhead on Tioga Road
for 5.2 miles (8.4 km) to the summit. 37°45'20" N 119°33'37" W

· WHITNEY PASSAGE ·

Josiah Whitney, State Geologist for California, 1870: There was at the
Yosemite a subsidence of a limited area, marked by lines of "fault"
or fissures crossing each other somewhat nearly at right-angles.
In other and more simple language, the bottom of the Valley sank
down to an unknown depth, owing to its support being withdrawn
from underneath, during some of those convulsive movements
which must have attended the upheaval of so extensive and elevated
a chain, no matter how slow we may imagine the process to have
been. Subsidence, over extensive areas, of portions of the earth's
crust, is not at all a new idea in geology, and there is nothing in this
peculiar application of it which need excite surprise.

· COMMENTARY ·

Until Muir started suggesting that glaciers and not cataclysmic
events played a major role in the formation of Yosemite, the
accepted version of the Valley's formation was the one put forth
by state geologist Josiah Whitney. Whitney and geologist Clarence
King later agreed with Muir that glaciers "played a significant
role in the formation of the High Sierra." Muir came to Yosemite
mostly a botanist, but eventually came to consider himself a
"poetico-trampo-geologist-botanist and ornithologist-naturalist
etc etc!!!!" Throughout the 1870s, Muir wrote more and more
about the "living glaciers of California," and he later devoted seven
trips to Alaska in twenty years to his continuing study of glaciers.

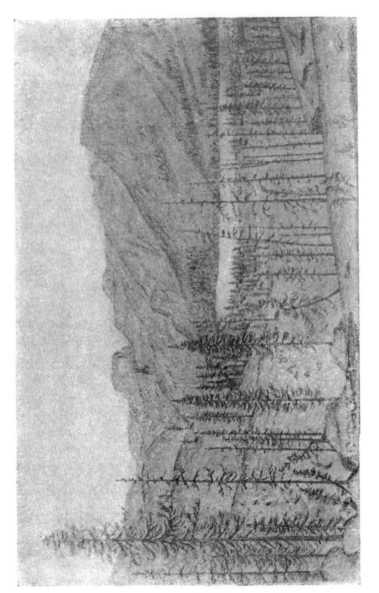

"View of Tenaya Lake showing Cathedral Peak," ca. 1887.

TENAYA LAKE

Similar views to the one in Muir's drawing can be found about
1 mile (1.6 km) along the way on this 1.5 mile (2.4 km) trail from
the May Lake trailhead parking area heading south toward Tioga
Road. 37°49'28" N 119°28'51" W

· MUIR PASSAGE ·

The largest of the many glacier lakes in sight, and the one with the
finest shore scenery, is Tenaya, about a mile long, with an imposing
mountain dipping its feet into it on the south side, Cathedral Peak
a few miles above its head, many smooth swelling rock-waves and
domes on the north, and in the distance southward a multitude
of snowy peaks, the fountain-heads of rivers. To the northward
the picturesque basin of Yosemite Creek glitters with lakelets and
pools; but the eye is soon drawn away from these bright mirror
wells, however attractive, to revel in the glorious congregation of
peaks on the axis of the range in their robes of snow and light.

· COMMENTARY ·

Chief Tenaya led the people of the Yosemite area, the
Ahwahneechee, until his death in 1853. They called this lake and
the canyon in which is sits "Py-we-ack," meaning "streams of
glistening rocks." An armed militia first entered Yosemite Valley
in 1851 to force the local native people onto a reservation far away.
Militia member Lafayette Bunnell renamed the lake for the chief
because that was where the militia had "found his people, who
would never return to it to live." When Tenaya was told of the new
name, his "countenance indicated that he thought the naming of
the lake no equivalent for the loss of territory."

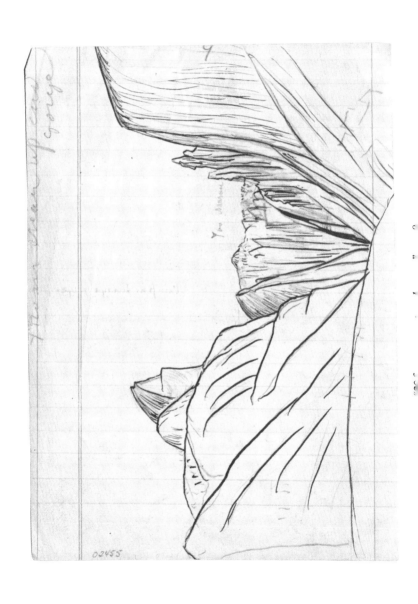

TENAYA CANYON

· LOCATION ·

The exact perspective of this view is from deep inside a trailless
Tenaya Canyon, but a similar view can be found about 2.5 miles
(4 km) up the Sunrise Lakes Trail from the trailhead at Tioga Road.
At the intersection of the Sunrise Lakes and Clouds Rest Trails,
head west on the unmarked trail about 400 feet (120 m) until you
come upon a grand vista. 37°48'03" N 119°27'37" W

· MUIR PASSAGE ·

I started up the canyon of Tenaya, caring little about the quantity
of bread I carried; for, I thought, a fast and a storm and a difficult
canyon were just the medicine I needed. This canyon is accessible
only to mountaineers. I scrambled around the Tenaya Fall and
was ascending a precipitous and smooth rock-front when I
suddenly fell—for the first time since I touched foot to Sierra
rocks. I became insensible, and when consciousness returned I
was trembling but not injured. "There," said I, addressing my feet,
"that is what you get by intercourse with stupid town stairs and
dead pavements." I was now awake and felt confident that the last
of the town fog had been shaken from both head and feet.

· COMMENTARY ·

Muir may have been trying to capture a glacier's view as it surged
down Tenaya Canyon. Here, Half Dome certainly looks like half of
a dome, but according to geologists only about 20 percent of the
original dome is missing. Likely, glaciers ran along below the full
dome and tore off rock that supported the face. The northwest
side of the dome collapsed over time, and glaciers carried and
pushed the rockfall toward the west end of the Valley. Half Dome,
like the rest of Yosemite's grand features, continues to erode, both
slowly and in spectacular and sometimes dangerous rockfalls.

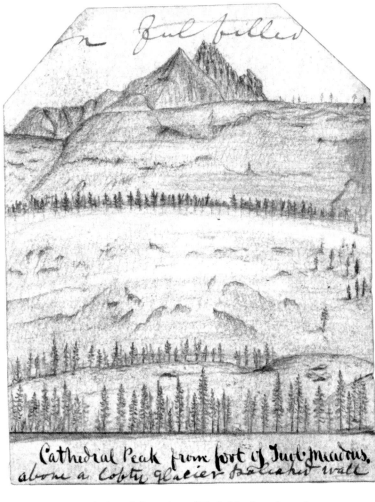

"Cathedral Peak from foot of Tuol. Meadows," ca. 1870.

Cathedral Peak

Walk 1 mile (1.6 km) to the summit of Pothole Dome from Tioga
Road for a view similar to Muir's sketch. 37°52'50" N 119°23'37" W

· MUIR PASSAGE ·

There is a cluster of conic, splintered granite peaks near where the
highest sources of the Tuolumne, Merced, and San Joaquin rivers
are small, sparkling, singing streams. One of these peaks is exactly
like an old cathedral and is called "Cathedral Peak." I rolled a
loaf of bread in a pair of blankets and started to explore these
mountains. I reached the top-most spires of the grand old church
about noon of the first day and sat down to rest and to eat. And
now Doctor [Muir's brother Daniel], here is a strange thing, I was
seated on the brink of a precipice about 7,000 feet in depth, and
in eating, whenever I looked up I was hungry, but when I looked
down I was full.

· COMMENTARY ·

The highest parts of Cathedral Peak extended above the highest
of the High Sierra glaciers, so instead of resembling a smooth,
rounded dome, it is a sharp, craggy point called a horn. Cathedral
Peak contains a specific type of granite-like rock—Cathedral
Peak Granodiorite—that was named after this location but can
be found throughout Tuolumne Meadows. Pieces of it were also
pushed and carried by glaciers down toward Yosemite Valley,
including one chunk that can now be found on the shoulder of
Half Dome, 10 miles (16 km) away and nearly 3,000 feet (915 m)
off the Valley floor.

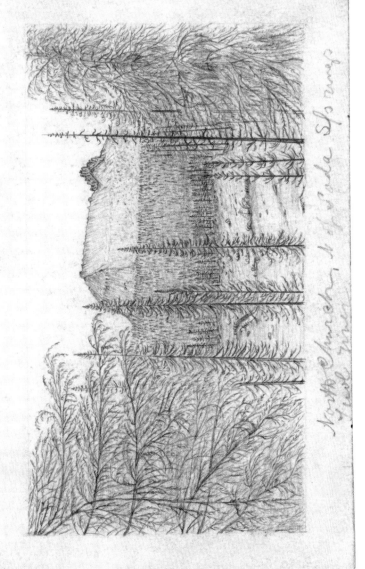

"North Church ... of Soda Springs Teal River", ca. 1865

Ragged Peak

Across the road from the Cathedral Lakes trailhead on Tioga
Road is a view similar to what Muir saw in the 1870s.
37°52'24" N 119°22'58" W

· MUIR PASSAGE ·

September 4, 1869. Almost all the plants have matured their seeds,
their summer work done; and the summer crop of birds and deer
will soon be able to follow their parents to the foothills and plains
at the approach of winter, when the snow begins to fly. *September 5.*
No clouds. Weather cool, calm, bright as if no great thing was
yet ready to be done. Have been sketching the North Tuolumne
Church [Ragged Peak]. The sunset gloriously colored. *September 6.*
Still another perfectly cloudless day, purple evening and morning,
all the middle hours one mass of pure, serene sunshine. Soon after
sunrise the air grew warm, and there was no wind. One naturally
halted to see what Nature intended to do.

· COMMENTARY ·

While camping in Tuolumne Meadows in 1889 with Robert
Underwood Johnson, an editor of *The Century Magazine*, Muir
was inspired to turn his writing efforts toward the preservation
of Yosemite as a national park. Johnson also encouraged Muir
to establish the Sierra Club, to, as Muir put it, "do something
for wildness and make the mountains glad." The two worked
together to get the state of California to cede its ownership
and management of the Mariposa Grove and Yosemite Valley
back to the federal government to become part of Yosemite
National Park, and Johnson helped in the fight against damming
Hetch Hetchy Valley. Muir wrote to him, "You don't know how
accomplished a lobbyist I've become under your guidance."

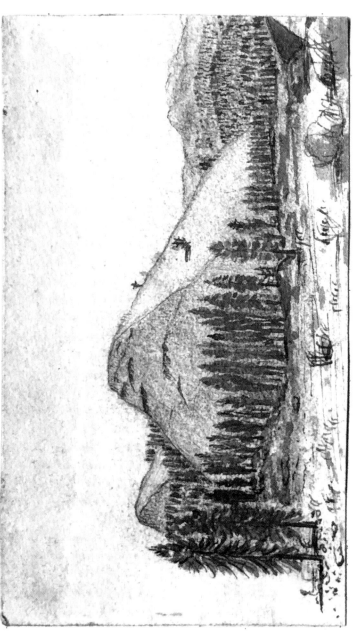

"View of moutonnéed rock from the basin of the Tuolumne mer de glace," ca. 1880.

Lembert Dome

The likely view site for this drawing is about .5 miles (.7 km) from Tioga Road on the trail to Soda Springs and Parsons Memorial Lodge, right before the bridge over the Tuolumne River. 37°52'37" N 119°21'58" W

· MUIR PASSAGE ·

The big Tuolumne Meadows are flowery lawns lying along the south fork of the Tuolumne River at a height of about eighty-five hundred to nine thousand feet above the sea and partially separated by forests and bars of glaciated granite. Here the mountains seem to have been cleared away or set back, so that wide open views may be had in every direction. The air is keen and bracing, yet warm during the day; and though lying high in the sky, the surrounding mountains are so much higher, one feels protected as if in a grand hall.

· COMMENTARY ·

Lembert Dome is an example of a roche moutonnée (or "sheep rock"), which is created when the glacier flows up one side of a dome and pulls rocks off the lee side, leaving an asymmetrical shape. Muir's work around these features convinced him to study the glacial origins of Yosemite. The longer he spent in the mountains seeking to understand them, the more he transitioned from an explorer who wrote to a writer who explored. In a letter to his sister Sarah, he penned an idea that has since become famous for the way in which it encapsulates both Muir's passion for this landscape as well as his commitment to the pursuit of knowledge: "The mountains are calling and I must go and I will work on while I can, studying incessantly."

Credits

Unless noted otherwise, images and source text are by John Muir. Images and text from University of the Pacific Libraries' Holt-Atherton Special Collections and Archives are either from the John Muir Papers © 1984 Muir-Hanna Trust (JMP) or the James Eastman Shone Collection of Muiriana (JESCM). These Muir drawings and texts, along with thousands of other sheets and pages of manuscript material, can be searched or browsed at scholarlycommons.pacific.edu/muir.

PAGES 10–11:
IMAGE: "Untitled" (North Dome, Royal Arches, Washington Column, Half Dome, Cook's Meadow). Drawing, ca. 1870. JMP.
MUIR PASSAGE: "Summering in the Sierra: John Muir, the Naturalist, Tells us Something about Yosemite Valley—How it Impresses the Visitor at Different Seasons." (San Francisco) *Daily Evening Bulletin,* June 14, 1875.
COMMENTARY: *Alaska Notes Summer of 1890.* Notebook, 1890. JMP.

PAGES 12–13:
IMAGE: "In Yosemite Val." Drawing, ca. 1870. JMP.
ROOSEVELT PASSAGE: Theodore Roosevelt to John Muir, May 19, 1903. JMP.
COMMENTARY: Theodore Roosevelt to John Muir, March 14, 1903. JMP.

PAGES 14–15:
IMAGE: "Sentinel Rock, Yosemite Valley." Drawing, ca. 1875. JMP.
MUIR PASSAGE: *The Yosemite.* New York: The Century Co., 1912: 78.
COMMENTARY: *Our National Parks.* Boston: Houghton Mifflin, 1901: 263–264.

PAGES 16–17:
IMAGE: "Cabin in Yo. Val." Drawing, 1869. JMP.
MUIR PASSAGE: [*Autobiography.*] Manuscript, ca. 1908, pages 295–296. JMP.
COMMENTARY: "Report of Resolutions Committee." *Bulletin of the California Conference of Social Work* 6, no. 4 (August 1923): 36.

PAGES 18–19:
IMAGE: John Muir to [sister] Sarah Galloway, April 5, 1871. JMP.
MUIR PASSAGE: John Muir to [sister] Sarah Galloway, April 5, 1871. JMP.
COMMENTARY: "John Muir in Yosemite. He Never Cut Down a Single Tree in the Valley. Twenty Years Ago He Was Employed by Mr. Hutchings to Saw Lumber From Fallen Timber." *Oakland Daily Evening Tribune*, September 14, 1890.

PAGES 20–21:
IMAGE: "From back of foot of Lower Yosemite Fall." Drawing, ca. 1869. JMP.
MUIR PASSAGE: *Yosemite, etc. [Part 2] 1872–1874, 1879 [circa 1887].* Notebook, ca. 1887. Image 35. JMP.
COMMENTARY: *The Yosemite.* New York: The Century Co., 1912: 41.

PAGES 22–23:
IMAGE: "Splendid white banner." *January–May 1873, Yosemite Fall, Ice Cone, etc.* Notebook, 1873. Image 38. JMP.
MUIR PASSAGE: *January–May 1873, Yosemite Fall, Ice Cone, etc.* Notebook, 1873. Image 39. JMP.
COMMENTARY: John Muir to [sister] Sarah Galloway, September 3, 1873. JMP.

PAGES 24–25:
IMAGE: "Point of observation." *Sierra Journal, Summer of 1869, v. 2, 1869 [ca. 1887].* Notebook, ca. 1887. Image 33. JMP.
MUIR PASSAGE: *My First Summer in the Sierra.* Boston: Houghton Mifflin, 1911: 159–160.
COMMENTARY: *My First Summer in the Sierra.* Boston: Houghton Mifflin, 1911: 160–161. *The Mountains of California.* New York: The Century Co., 1894: 79.

PAGES 26–27:
IMAGE: John Muir to [daughter] Wanda Muir, July 16, 1884. 1–2. JMP.
MUIR PASSAGE: John Muir to [daughter] Wanda Muir, July 16, 1884. 1–2. JMP.
COMMENTARY: John Muir to Jeanne C. Carr, October 16, 1873. JMP.

PAGES 28–29:
IMAGE: "Ice cone at foot of Upper Yosemite Fall." Drawing, ca. 1890. JMP.
MUIR PASSAGE: *The Yosemite.* New York: The Century Co., 1912: 47.

PAGES 30–31:
IMAGE: "Illilouette Fall in winter." *Yosemite, etc. [Part 2] 1872–1874, 1879 [circa 1887].* Notebook, ca. 1887. Image 20. JMP.
MUIR PASSAGE: *The Yosemite.* New York: The Century Co., 1912: 34–35.
COMMENTARY: Whitney, Josiah. *The Yosemite Guide-Book: A Description of the Yosemite Valley and the Adjacent Region of the Sierra Nevada, and of the Big Trees of California, illustrated by maps and woodcuts.* Cambridge, MA: University Press: Welch, Bigelow and Co., 1870: 17.

PAGES 32–33:
IMAGE: "In Yosemite looking down Nevada Cañon." Drawing, ca. 1873. JMP.
MUIR PASSAGE: *November 1869—circa August 1870, Yosemite Year Book.* Journal, 1869–1870. Image 33. JMP.
COMMENTARY: Browning, Peter. *Yosemite Place Names: The Historic Background of Geographic Names in Yosemite National Park.* Lafayette, CA: Great West Books, 1988: 96.

PAGES 34–35:
IMAGE: "Untitled" (Liberty Cap and Nevada Fall). Drawing, ca. 1873. JESCM.
MUIR PASSAGE: *The Yosemite.* New York: The Century Co., 1912: 31.
COMMENTARY: Harwell, C. A. "A Rare Muir Entry Found in Yosemite." *Yosemite Nature Notes* 9, no. 2 (1930): 10. "Snows," National Park Service website, https://www.nps.gov/yose/learn/historyculture/snow.htm.

PAGES 36–37:
IMAGE: "Untitled" (Royal Arches and Washington Column). Drawing, ca. 1873. JMP.
MUIR PASSAGE: "In the Yo-Semite. Holiday among the Rocks. Yo-Semite Valley, January 1, 1872." *New York Weekly Tribune*, March 13, 1872, 3.
COMMENTARY: Huber, Norman King. *The Geologic Story of Yosemite National Park.* U.S. Geological Survey Bulletin 1595. Washington, D.C.: Government Printing Office, 1987: 34. Kiver, Eugene P., and David V. Harris. *Geology of U.S. Parklands.* New York: Wiley and Son, 1999: 222.

PAGES 38–39:
IMAGE: "Samoset. Mariposa Grove. Named by Emerson." Drawing, 1875. JESCM.
MUIR PASSAGE: *[Autobiography.]* Manuscript, ca. 1908, pages 258 and 266. JMP.
COMMENTARY: "Summering in the Sierra: John Muir Shakes the Dust of the Town from his Feet and Flees to the Mountains." (San Francisco) *Daily Evening Bulletin*, July 13, 1876.

PAGES 40–41:
IMAGE: "Lower end Yosemite Val. from top of s. wall." Drawing, ca. 1870. JMP.
MUIR PASSAGE: *The Yosemite.* New York: The Century Co., 1912: 12–13.
COMMENTARY: Chisholm, Dianne. "Climbing like a Girl: An Exemplary Adventure in Feminist Phenomenology." *Hypatia* 23, no. 1 (2008): 9–40.

PAGES 42–43:
IMAGE: "Hetch Hetchy from near Wa-pa-ma Falls." Drawing, ca. 1895. JMP.
MUIR PASSAGE: *Trip Down Tuolumne Canyon.* Journal, July–September 1895. Image 18. JMP.
COMMENTARY: *The Yosemite.* New York: The Century Co., 1912: 262.

PAGES 44–45:
IMAGE: "Old dead giant of the Tuolumne Sequoia grove." Drawing, ca. 1869. JMP.
MUIR PASSAGE: *My First Summer in the Sierra.* Boston: Houghton Mifflin, 1911: 350–351.
COMMENTARY: Quin, Richard. Historic American Engineering Record, National Park
 Service, U.S. Department of the Interior, *Big Oak Flat Road (HAER No. CA-147)
 written historical and descriptive data,* 1991.

PAGES 46–47:
IMAGE: "Illilouette Fall." Drawing, ca. 1872. JMP.
MUIR PASSAGE: [*Autobiography.*] Manuscript, ca. 1908, page 454. JMP.
COMMENTARY: [*Autobiography.*] Manuscript, ca. 1908, page 455. JMP.

PAGES 48–49:
IMAGE: "Yosemite Valley from top of North Dome." Drawing, 1869. JESCM.
WHITNEY PASSAGE: Whitney, Josiah. *The Yosemite Guide-Book: A Description of the
 Yosemite Valley and the Adjacent Region of the Sierra Nevada, and of the Big Trees of
 California, illustrated by maps and woodcuts.* Cambridge, MA: University Press: Welch,
 Bigelow and Co., 1870: 85.
COMMENTARY: John Muir to Robert Underwood Johnson, September 13, 1889. From The
 Bancroft Library, University of California at Berkeley.

PAGES 50–51:
IMAGE: "Tenaya Lake," *My First Summer in the Sierra.* Boston: Houghton Mifflin, 1911: 263.
MUIR PASSAGE: *My First Summer in the Sierra.* Boston: Houghton Mifflin, 1911: 206–207.
COMMENTARY: Bunnell, Lafayette Houghton. *Discovery of the Yosemite, and the Indian war
 of 1851, Which Lead to that Event.* Chicago: Fleming H. Revell, 1880: 237.

PAGES 52–53:
IMAGE: "Y from near up end gorge." Drawing, ca. 1870. *Principles of Physics or Natural
 Philosophy.* Notebook, 1861 and ca. 1870. Image 43. JMP.
MUIR PASSAGE: *Steep Trails.* Edited by William Fredric Badè. Boston: Houghton Mifflin,
 1918: 20.
COMMENTARY: Glazner, Allen F., and Greg M. Stock. *Geology Underfoot in Yosemite
 National Park.* Missoula, MT: Mountain Press Publishing Company, 2010: 146.

PAGES 54–55:
IMAGE: "Cathedral Peak from foot of Tuol. Meadows." Drawing, ca. 1870. JESCM.
MUIR PASSAGE: John Muir to [brother] Daniel Muir, September 24[, 1869]. From the
 Huntington Library, San Marino, CA.
COMMENTARY: Glazner, Allen F., and Greg M. Stock. *Geology Underfoot in Yosemite
 National Park.* Missoula, MT: Mountain Press Publishing Company, 2010: 23, 27.

PAGES 56–57:
IMAGE: "North Church, n. of Soda Springs, Tuol. River." Drawing, ca. 1870. JESCM.
MUIR PASSAGE: *My First Summer in the Sierra.* Boston: Houghton Mifflin, 1911: 328–329.
COMMENTARY: John Muir to Henry Senger, May 22, 1892. Badé, William Frederic. *The
 Life and Letters of John Muir.* Vol. II. Boston: Houghton Mifflin, 1924: 357.

PAGES 58–59:
IMAGE: "View of moutonnéed rock from the basin of the Tuolumne mer de glace." From
 "The Ancient Glaciers of the Sierra." Manuscript, ca. 1880. JMP.
MUIR PASSAGE: *My First Summer in the Sierra.* Boston: Houghton Mifflin, 1911: 266–267.
COMMENTARY: Glazner, Allen F., and Greg M. Stock. *Geology Underfoot in Yosemite
 National Park.* Missoula, MT: Mountain Press Publishing Company, 2010: 155.
 John Muir to [sister] Sarah Galloway, September 3, 1873. JMP.

Acknowledgments

I leaned on a lot of folks to make this book possible. First is family: Me lovely lass and wife, Sheryl Beverett, and her children, Kimberly and Kurtis; my perfect parents, Jim and Shirley Wurtz; and my such-a-good-girl Marcie the dog. Also, my siblings and their families: Kenna, Jim, and Celeste Fenton; Ron, Karen, Finn, and Signe Wurtz; and Tom, Merri, Zane, and Max Wurtz.

For his time in scouting sites with me, I can't thank Bob Hare enough. His interest in and knowledge of Muir's drawings is amazing, and I look forward to his book someday. Bobby Nguyen, Nobuyuki Shiraishi, Josh Salyer, Nicole Grady, Niraj Chaudhary, Ron Wurtz, Veronica and David Wells, David White, and Dan Cosper have all enthusiastically or reluctantly joined me on the hunt as well.

I also want to thank Kurtis Burmeister, from the University of the Pacific's geology program. He may be the only person I heed when he says, "You know what you should do is..." Others who helped me understand what the heck it was that I was doing through offering conversation, support, and friendship include Bill Swagerty, Lydia Fox, Kerrigan Börk, Laura Rademacher, Bonnie Gisel, Shan Sutton, Keith Hatschek, Frank Helling, Samantha Martinez, Amy Eastberg, Andrew May, Alex McCurdy, Joseph Olson, Dave Jennings, Alex Poirier, Charles Berolzheimer, Alice van Ommeran, KC Greaney, Michael Conti, Nicole Geiger, Jeffrey Trust, Pete Devine, and Lisa Marietta. Thanks also goes to University of the Pacific Libraries' Mary Somerville, Robin Imhof, Trish Richards, and my other wonderful colleagues there; to Jennifer Juanitas and DeeLynn Rivinius at the Osher Lifelong Learning Institute at the University of the Pacific; and to the Faculty Research Committee's Scholarly/Artistic Activities Grant for their support.

I also want to thank the descendants of John Muir who have trusted Pacific since 1970 to preserve his journals, notebooks, letters, drawings, manuscripts, and other Muiriana, and to share Muir's message with the world.

About the Author

Mike Wurtz is an associate professor at the University of the Pacific and the head of the University Libraries' Holt-Atherton Special Collections and Archives, home of the largest collection of Muiriana. He holds master's degrees in both history and library science and a bachelor's in geography, and he has given dozens of presentations about John Muir. Mike co-leads field trips for Pacific students to the eastern Sierra, the Colorado Plateau, and Muir's homes in Scotland and Martinez, California. He also guides Osher Lifelong Learning Institute participants and other groups on tours of Yosemite, helping them see the park through Muir's eyes.

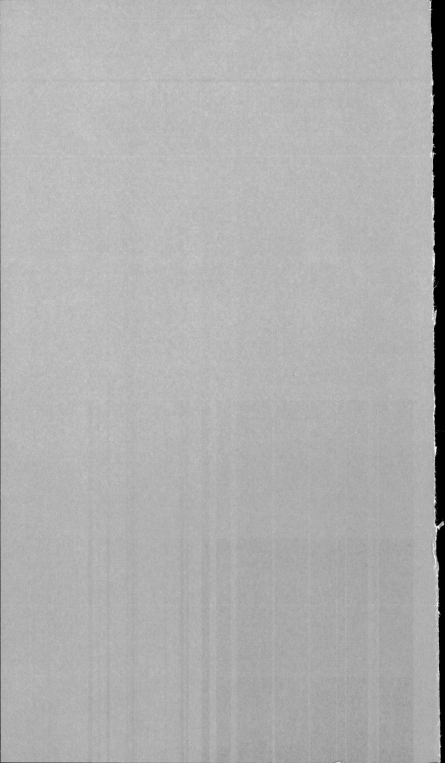